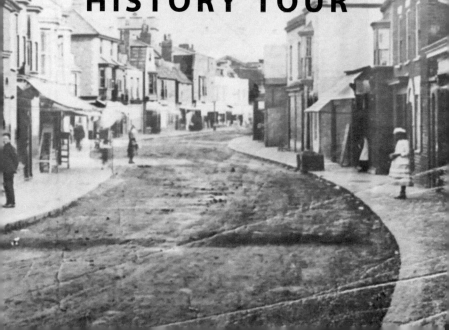

WHITSTABLE

HISTORY TOUR

First published 2022

Amberley Publishing
The Hill, Stroud,
Gloucestershire, GL5 4EP
www.amberley-books.com

Copyright © Kerry Mayo, 2022
Map contains Ordnance Survey data
© Crown copyright and database
right [2022]

The right of Kerry Mayo to be
identified as the Author of this work
has been asserted in accordance with
the Copyrights, Designs and Patents
Act 1988.

ISBN 978 1 3981 0277 4 (print)
ISBN 978 1 3981 0278 1 (ebook)

British Library Cataloguing in
Publication Data.
A catalogue record for this book is
available from the British Library.

Origination by Amberley Publishing.
Printed in Great Britain.

KEY

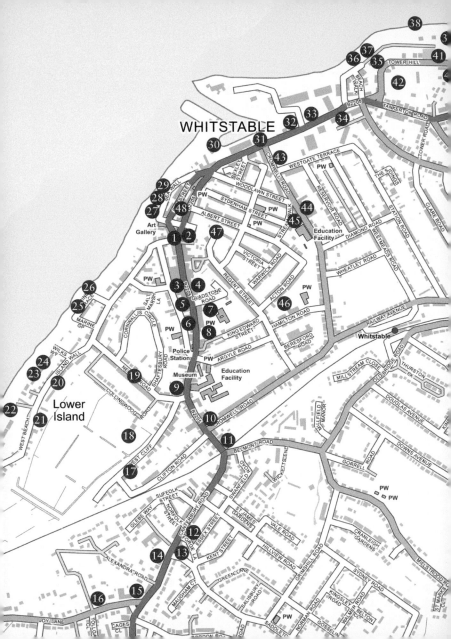

INTRODUCTION

Whitstable sits on the north Kent coast with its back to the sun and its picnic basket full of delights waiting to be unpacked.

Take a walk down the vibrant High Street with thriving local restaurants and smart high-street shops sitting alongside art galleries and boutiques. Follow the line of the old shore along Oxford Street, under the railway bridge constructed in 1860, and out to the Tollgate where you would be charged to use the Canterbury–Whitstable turnpike – unless you were a funeral or wedding party.

After walking part of Joy Lane – one of Whitstable's most exclusive addresses – cut through to West Cliff, which marks the line of flooding in 1953, the golf course to the left having been completely submerged. Then walk down Island Wall – the other contender for best place to live – and enviously eye the properties close enough to the beach to hear the waves break on the pebbles.

Walk back along the seafront, where the sea has frozen many times, and into the harbour designed by Robert Stephenson and opened in 1832. Shipbuilding and colliers delivering coal from the North East once dominated this seaside town and there remains a successful fishing industry. Spot where the Canterbury–Whitstable Railway lines once brought tourists to the harbour and took goods from the trading ships to Canterbury.

Then head to the tranquil environs of Tankerton with its stunning Street, a shingle spit that juts out into the sea for half a mile at low tide; on to Whitstable Castle, a pretty summer home for the rich and famous of yesteryear, now a community resource; and back down into town, through streets once bombed in the Second World War.

Conclude your walk in Harbour Street, home to independent traders and exclusive goods, and treat yourself in this café-culture hub. You've earned it.

1. THE DUKE OF CUMBERLAND HOTEL

The original pub on this site was called Noah's Ark and was renamed the Duke of Cumberland in 1748 in honour of Duke William, who had crushed the Scottish rebellion at Culloden a year earlier. It was rebuilt after a fire in 1866 and modernised in 1900. It is owned by the Shepherd Neame Brewery and is known for its live music and Salt Marsh restaurant.

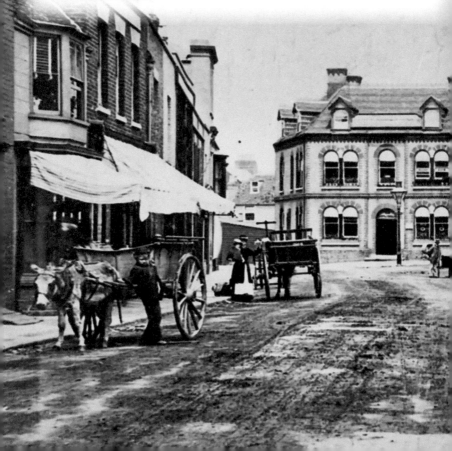

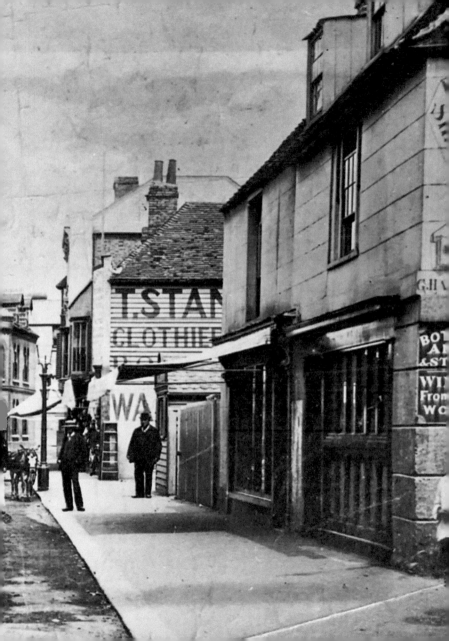

2. THE BEAR AND KEY HOTEL AND PREZZO

The original pub on this site was called The Ship until William Hogsflesh, its licensee, changed the name to the Bear and Key Hotel in 1739. This early photograph shows two doorways: the left was later replaced with a window, and the archway to the right led to stables and coach houses. The Bear and Key Hotel closed in 2001 to be reincarnated as Sherrins, but this too closed in 2002. It has been home to Prezzo since 2007.

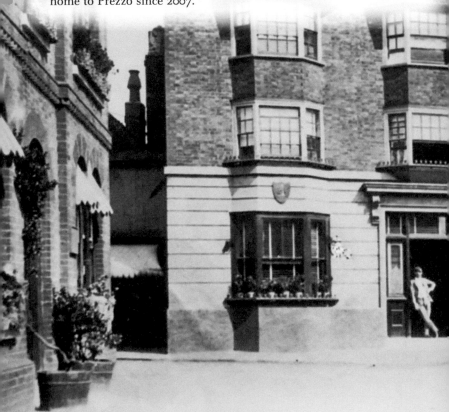

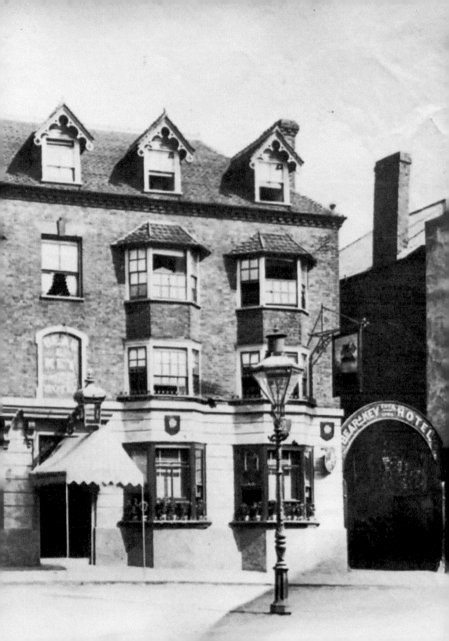

3. CINEMA AND SAINSBURY'S

The cinema operated as The Picture House between 1913 and 1937, then as the Argosy, and after the Second World War as The Regal, before finally closing in the 1960s. It was remodelled and opened as the town's first major supermarket, a Fine Fare, later Somerfield, then Budgens and now Sainsbury's. It also previously housed the town's first Chinese restaurant on the first floor.

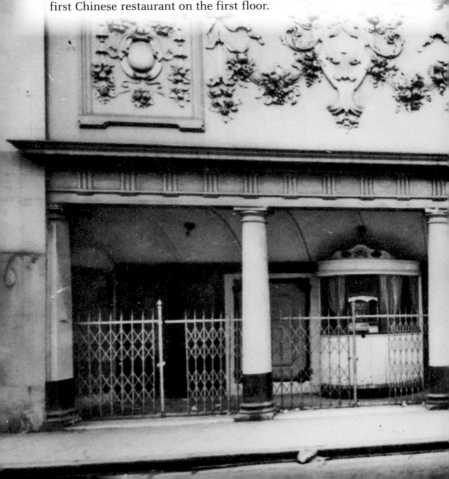

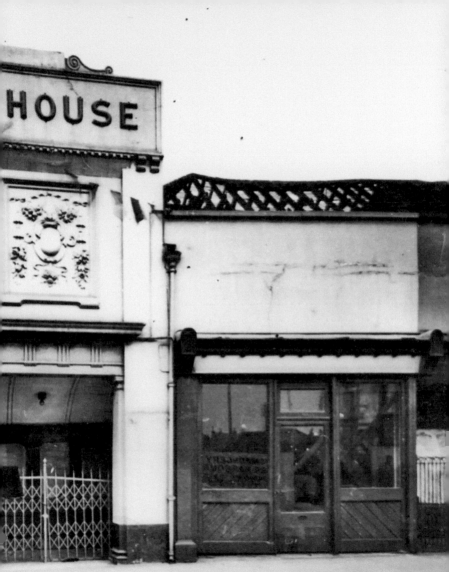

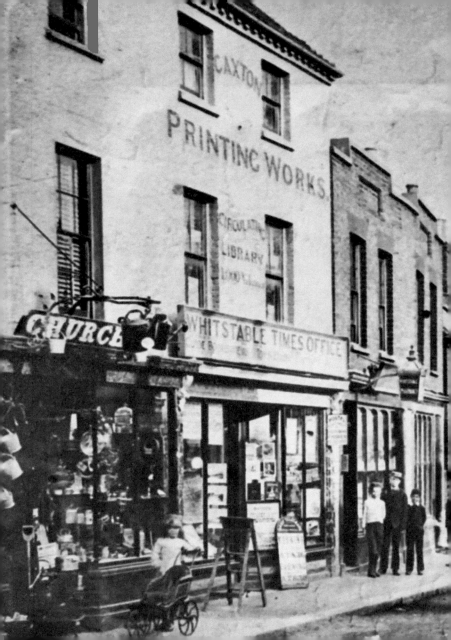

4. HIGH STREET

Seen here in this early image from around 1900, Caxton's Printing Works was established in 1863, later operating as Cox's newsagents until around 2005. The Circulation Library was a place to rent books, and St George Church's ironmongery shop became Arthur Collier's Ltd, a builders' merchant, now a Boots pharmacy.

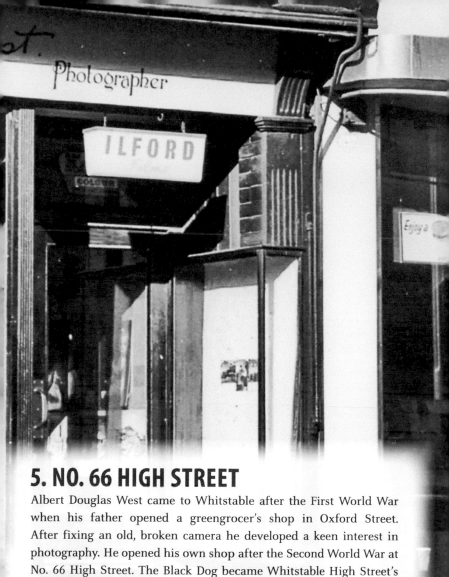

5. NO. 66 HIGH STREET

Albert Douglas West came to Whitstable after the First World War when his father opened a greengrocer's shop in Oxford Street. After fixing an old, broken camera he developed a keen interest in photography. He opened his own shop after the Second World War at No. 66 High Street. The Black Dog became Whitstable High Street's first micropub on 22 September 2013.

6. CONGREGATIONAL CHURCH AND PLAYHOUSE THEATRE

This impressive building was originally the Congregational Church, which occupied the site from 1792. Destroyed by fire on 5 October 1854 but rebuilt a year later, it was enlarged just after the First World War, when the small shop on the right was demolished to make way for it. The Playhouse Theatre took over the building in 1981 and carried out substantial works to the building's interior before opening with *A Voyage Round My Father* in 1982.

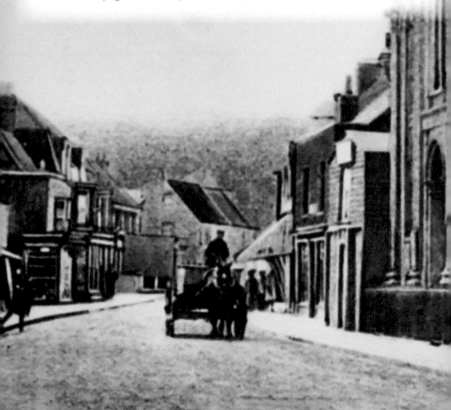

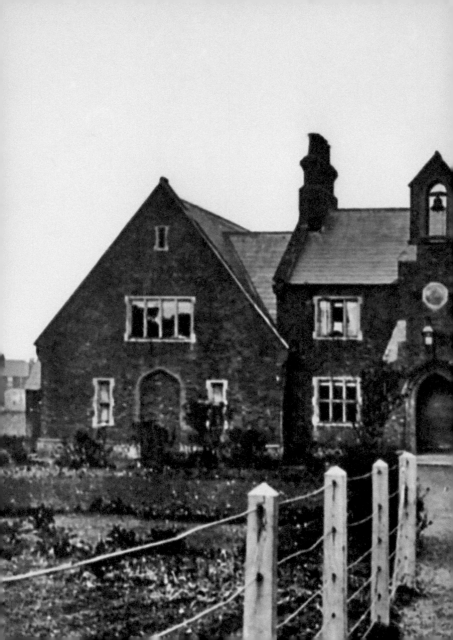

7. WHITSTABLE AND SEASALTER ENDOWED CHURCH OF ENGLAND JUNIOR SCHOOL

Built in 1845, the same year as St Alphege Church, the 'Endowed', as it is known, was designed to educate 400 children. While easily recognisable, there have been some alterations, most notably changes to the windows and the removal of the bell turret and bell.

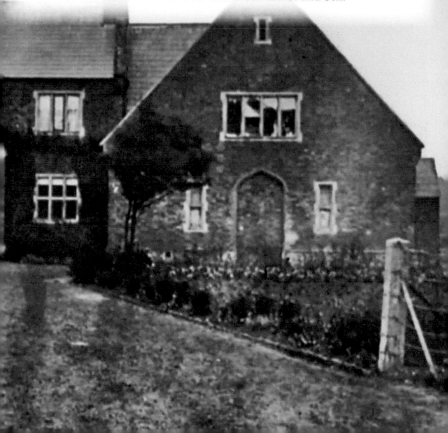

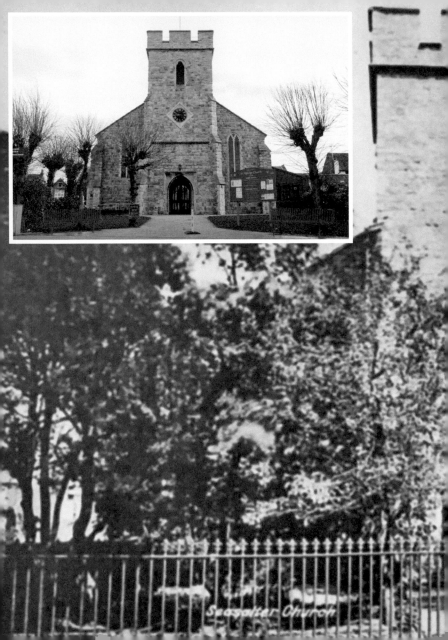

Seagalter Church

8. ST ALPHEGE CHURCH

In the 1830s, pastoral care in the Whitstable and Seasalter parishes was much neglected, so a new curate was appointed in 1837. He found a population of 8,000 people with few who observed 'the Lord's Day', and 'even the shops [were] not shut'. The new St Alphege Church, 2 miles west of the church it replaced, was consecrated on 9 October 1845 by the Archbishop of Canterbury. The railings were removed during the Second World War to aid the war effort.

9. OXFORD STREET

William Somerset Maugham attended a school here run by a Miss Etheridge, a relation of Lord Nelson. His uncle, Henry Maugham, was his guardian after his parents' early death and vicar of All Saints Church (1871–97), although his relationship with the young Maugham was apparently cold. They lived in a large vicarage on Canterbury Road after the boy arrived in 1884, aged ten. As an adult, Maugham wrote of the fictitious town of Blackstaple, thought to be based on Whitstable.

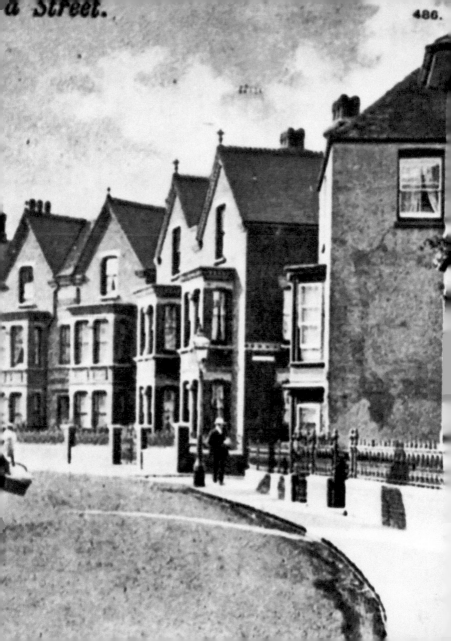

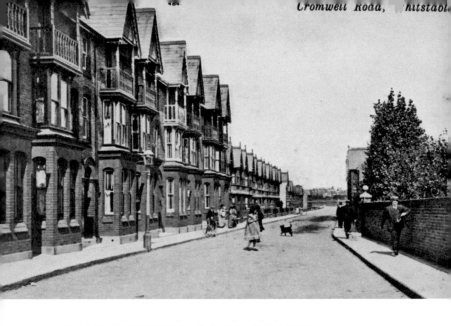

10. CROMWELL ROAD SOUTH

This imposing terrace was built around the turn of the twentieth century by Amos & Foad, who were based in Millstrood Road with an office on Oxford Street. They also built the Pavilion building at the entrance of Herne Bay Pier in 1884, which was later enlarged and subsequently destroyed by fire.

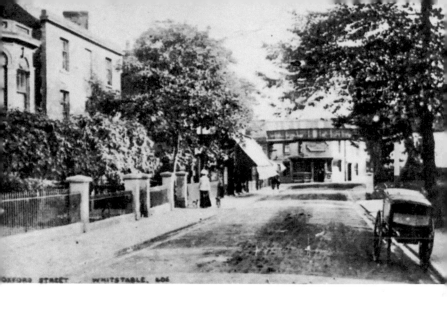

OXFORD STREET WHITSTABLE. 405

11. RAILWAY BRIDGE, OXFORD STREET

The bridge was erected in 1860 to carry trains along the new main line from London to Whitstable and beyond. Through the bridge the old Railway Inn is visible, though it is now closed. On the left, the railings and brick pillars are all gone, as are the mature trees. Gone too are the box trucks, seen here on the right, which were commonly used for delivering goods.

12. CORNER OF CANTERBURY ROAD AND FORGE LANE

Owned by Thomas Browning, No. 97 Canterbury Road must have been one of the largest buildings in town around 1880, and was his home and his coal yard. Coal from the north-east arrived in the harbour nearly every day and was brought here before being distributed among the residents of the town. Although gas came to Whitstable in 1854, it was only used for lighting. Today, a row of terraced cottages occupies the site.

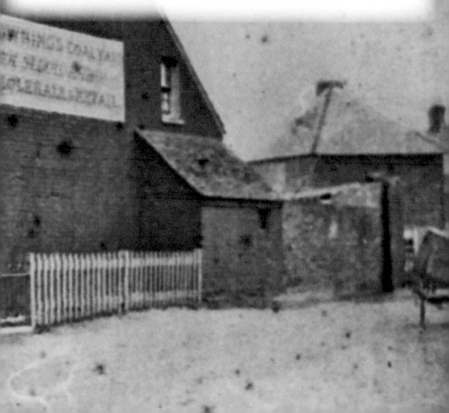

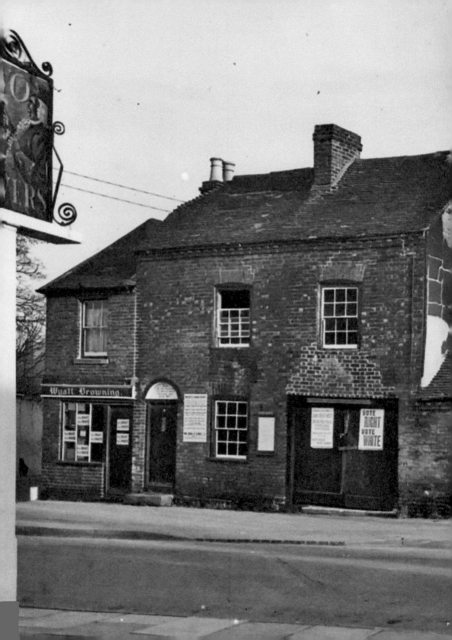

13. THE OLD FORGE, CANTERBURY ROAD

Built in the late 1700s, the business lasted more than 200 years until the coming of the motor car precipitated the demise of many small forges. In January 1934, Charles Dilnott, farrier, murdered the blacksmith William Percy Wills here before committing suicide. Wyatt Browning's furniture and upholstery shop was on the corner of Forge Lane. The buildings are now home to an accountancy firm.

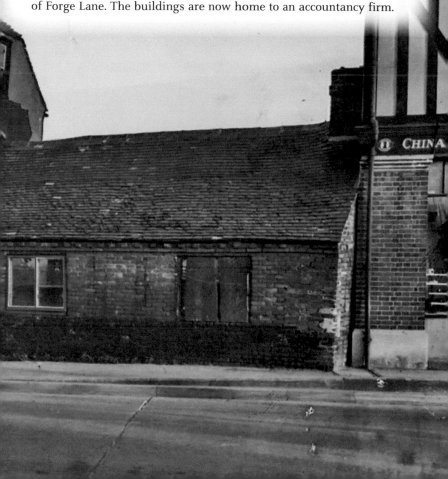

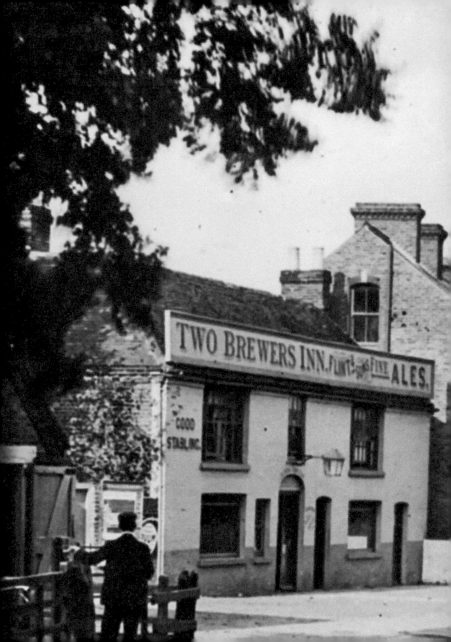

14. THE TWO BREWERS, CANTERBURY ROAD

Supposedly the oldest surviving pub in Whitstable, the Two Brewers has been a public house since 1723, although the building is seventeenth century and was originally built as farm cottages. Merchants using the Whitstable–Canterbury road could rent strong horses to haul their carts up the steep slope of Borstal Hill, where their own horses would have struggled. The Two Brewers faced Grince Green, site of the Dredgerman's Fair held in summer on the day of the patron saint of oystermen, St James.

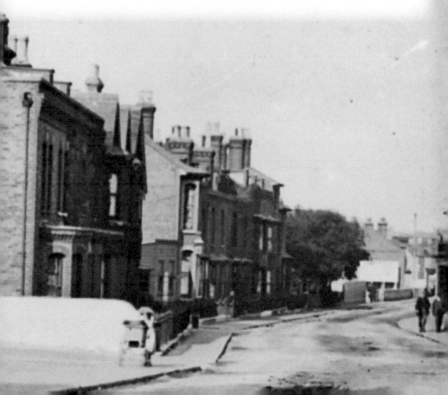

15. THE TOLLGATE

The incoming railway line from London meant the Tollgate had to move from its original home at the junction of Canterbury Road and Oxford Street. In 1860, it was relocated to its present location on the corner of Joy Lane, at the bottom of Borstal Hill. Tolls were charged for the Canterbury–Whitstable turnpike road from 1736 to 1871, excepting funerals and wedding parties. The building spent some time as a tea room and local store but is now a private house.

Canterbury Road, Whitstable

16. BARN HOUSE, JOY LANE

The two roofs to the right formed the original barn, which was built in the fifteenth century and used for many years as part of Joy Farm. George Reeves, local builder, bought the buildings in 1907 with the plan to reuse the materials for new developments before discovering the historical value of the wattle plastering and king post truss in the roof. Subsequently, he added the Tudor-style cottage, and the three buildings formed a single residence.

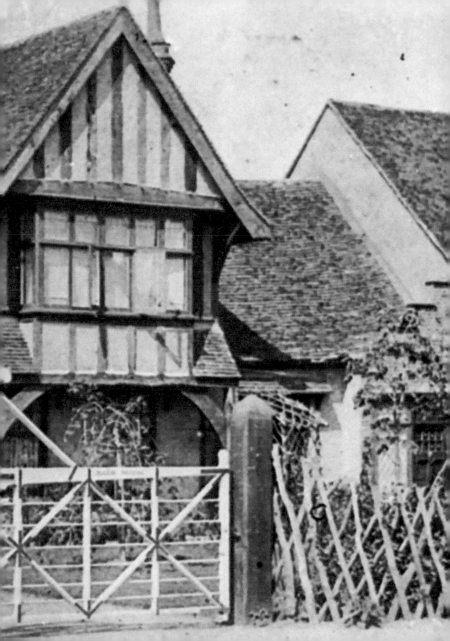

17. WEST CLIFF

Children would ride in a goat chaise as a means of transport and entertainment, and they were popular around Whitstable and Tankerton during the summer months. Here, at West Cliff, prior to 1910, the field to the left is yet to be developed as part of the Seasalter Golf Club. West Cliff was once the shoreline, and references have been found to marine craft and early oyster dredgers being moored over 'The Salts', the present site of Seasalter Golf Course.

18. WHITSTABLE AND SEASALTER GOLF CLUB

In 1911, the Seasalter Golf Club was formed on land that had once been sea, then salt pans, then grazing land for sheep. It was designed for people at the Whitstable end of town 'who would never go so far afield as Tankerton to play', according to Mr A. J. Wilson, founding member. The course, and the town, flooded on 31 January 1953, almost leading to the financial ruin of the club. Happily, play continues today.

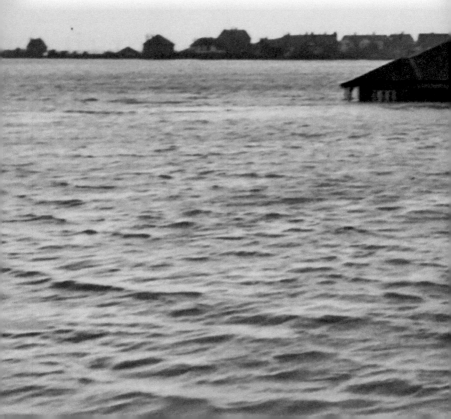

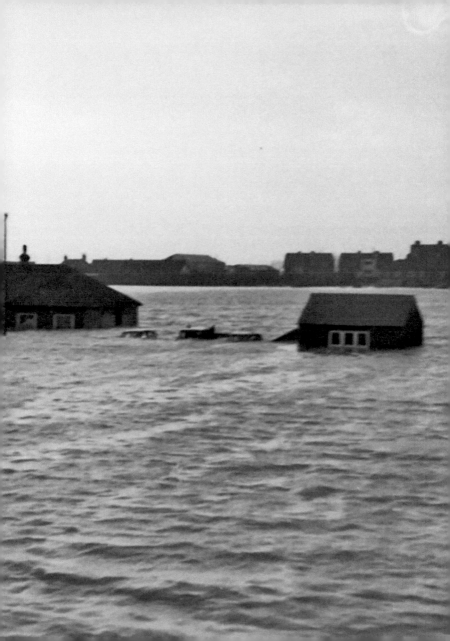

19. NELSON ROAD

In 1953, the floodwater in Nelson Road reached the middle sash of the windows on the ground floor of the houses, but had receded slightly by the time of this photograph, leaving behind its watery mark. Rowing boats were used to rescue people from their upstairs windows. Around 160 years earlier, the shoreline would have been along the line of Oxford Street and West Cliff, and Nelson Road would have been submerged.

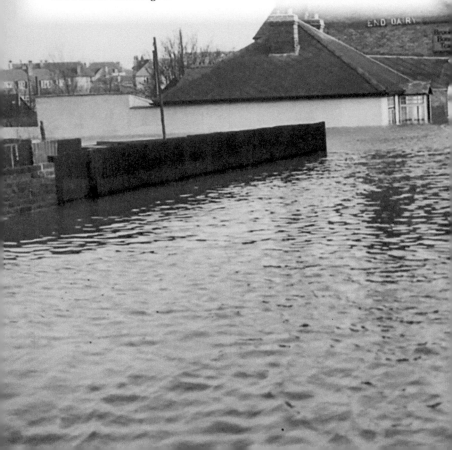

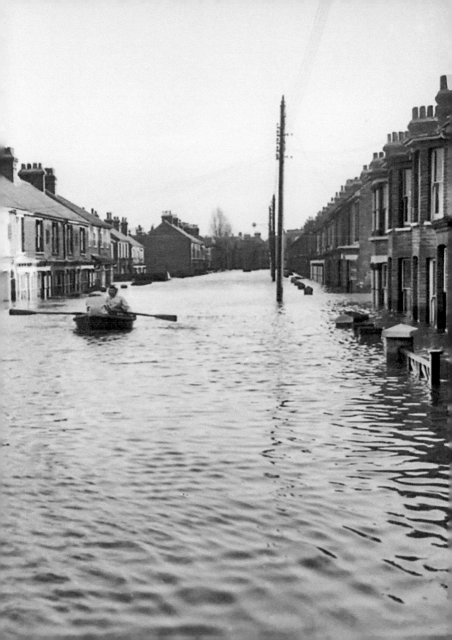

20. ISLAND WALL

Part of Whitstable's early flood defences, Island Wall is one of Whitstable's most desirable locations. It is home to Dollar Row (not pictured), a run of cottages reputedly built with the spoils from a wreck off the west coast of Ireland. Divers from Whitstable went out in 1851 and returned with a hoard of Spanish dollars. By 1860, Whitstable had thirty to fifty divers who went down to wrecks to recover valuables, with air piped to them by tube up to 100 feet underwater.

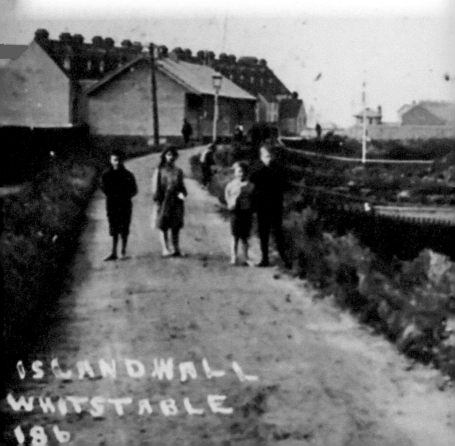

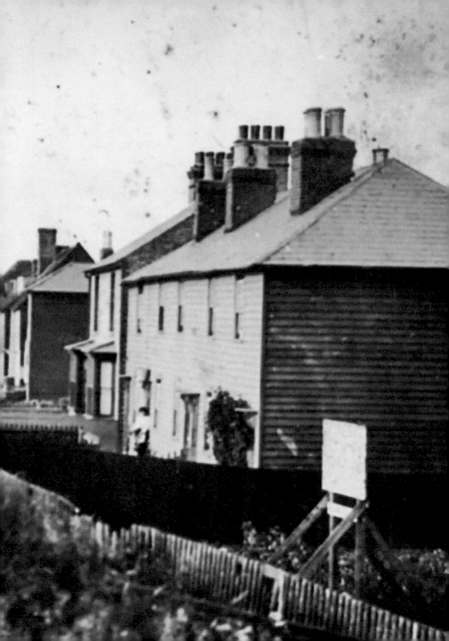

21. STAR HOUSE, LOWER ISLAND WALL

As the Star public house, it was a popular place with the workers in the shipyards that were once at this end of town. As Star House, it belonged to the son of Lord Fisher of Lambeth (the Archbishop of Canterbury), and Lord Fisher himself resided there for a time. The house backs onto the Seasalter Golf Course and is difficult to recognise as the building it once was.

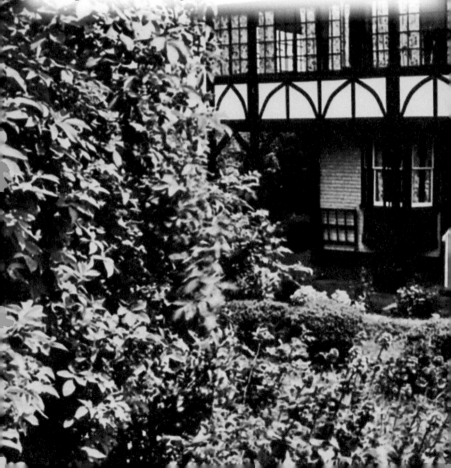

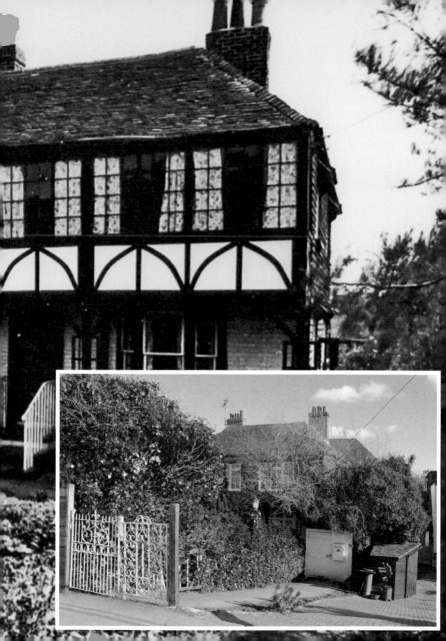

22. THE 'WEST END'

Seawater freezes at different temperatures depending on how much salt it contains. The resulting ice is very low in salt and the water can be melted down as drinking water. The large volume of river water in the Medway Estuary accounts for the sea freezing at Whitstable, as it has done many times: in 1895, when it froze up to 200 yards from the shore; 1929 (seen here); 1938; 1940; 1947; 1956; 1958; and most recently in 1963.

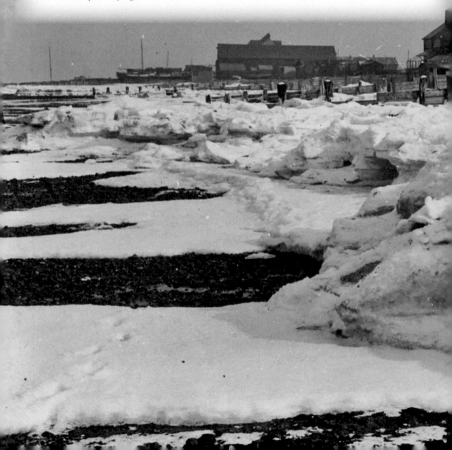

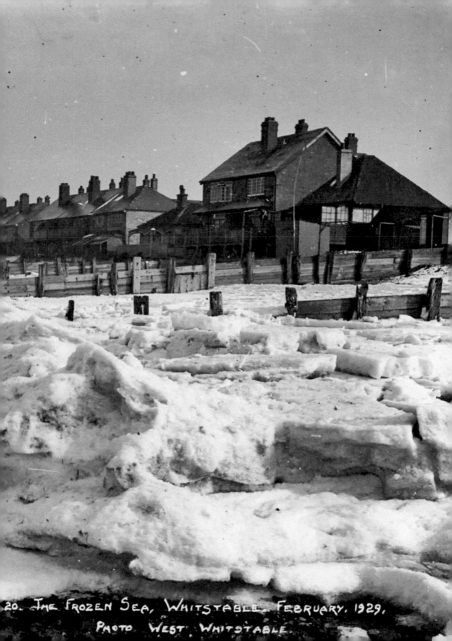

20. THE FROZEN SEA, WHITSTABLE, FEBRUARY, 1929.
PHOTO WEST, WHITSTABLE.

23. WEST BEACH LOOKING EAST

A view of West Beach looking east at low tide. Sailing vessels are moored offshore as well as in the harbour, their tall masts clearly visible over the tops of the buildings. The old Whitstable pier (1913–56) can be seen just to the left of the Old Neptune. It was constructed from timbers from a ship called the Herbert, which was broken up.

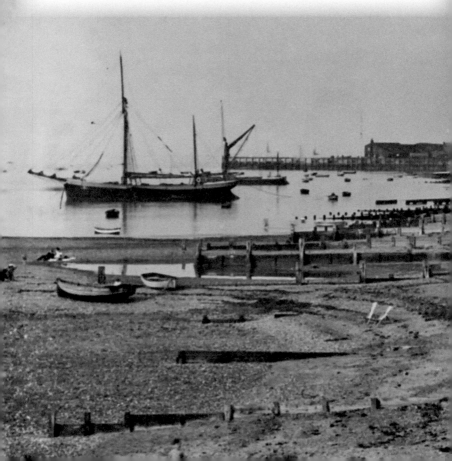

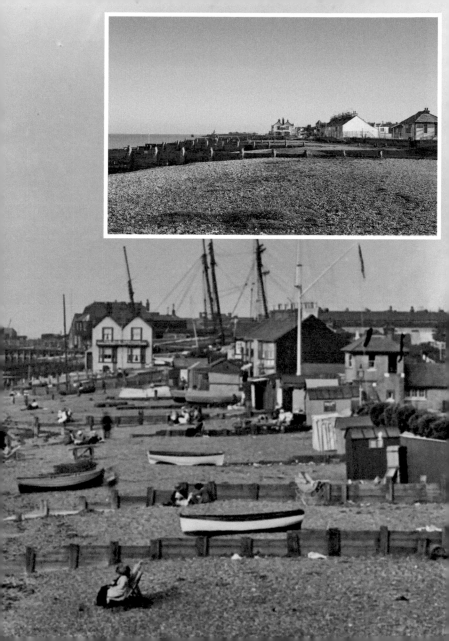

24. WAVE CREST TERRACE

Built in the 1890s, Wave Crest Terrace was to provide up-to-date seafront accommodation for visitors. The original Old Neptune pub, destroyed in 1897, is visible in the distance in this earlier shot, which dates the image to somewhere around the mid-1890s. The shingle beach is the first line of flood defence as it breaks up the waves and absorbs their energy. The beaches in Whitstable were widened in the 1980s with shingle dredged from the English Channel loaded onto the foreshore.

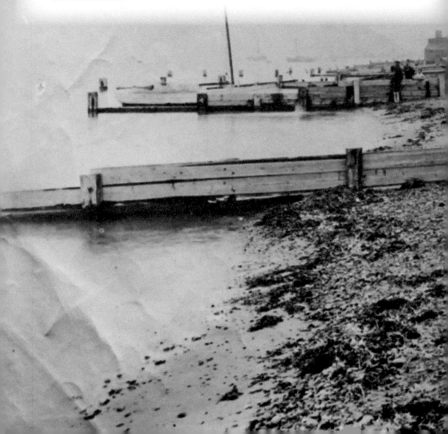

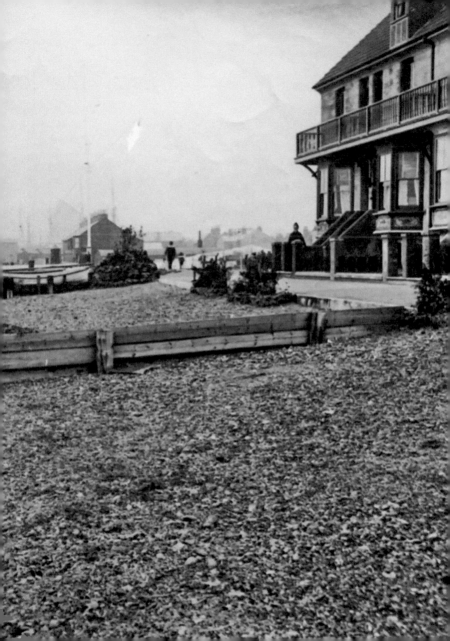

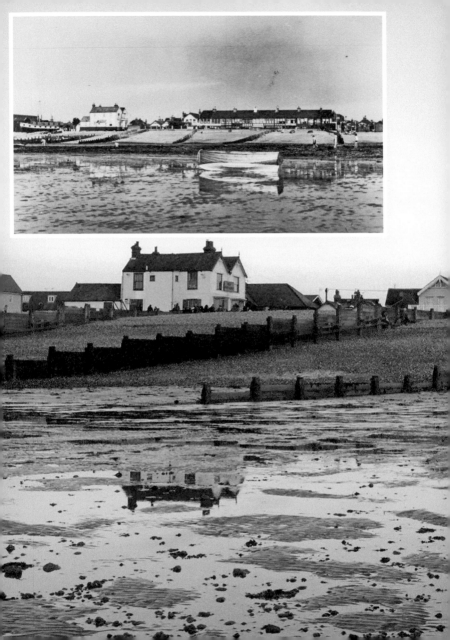

25. MARINE TERRACE FROM THE SEA

The house on the far right of Marine Terrace was owned by the Seasalter & Ham Oyster Fishery Company, who had their office there. A race between the oyster farmers of the Thames Estuary took place at the start of each season, with the first to get their oysters to Billingsgate the winner. Next door, where there are tennis courts today, were salt pans and a large boiling shed of the sea salt business, used to evaporate the water.

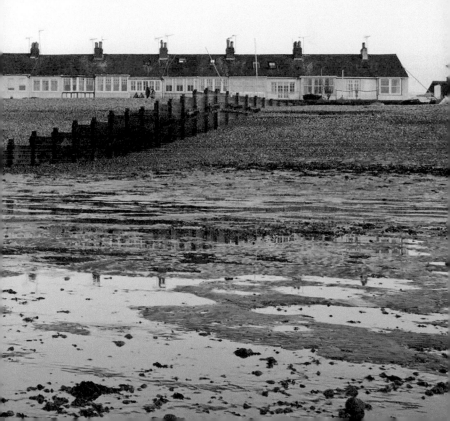

26. THE OLD NEPTUNE

Originally a boatbuilding workshop, the pub dates from 1852 and was named after an old oyster smack that was used as a breakwater. The original Old Neptune pub was swept away in the great storm and flood of November 1897. The new Old Neptune was relocated to its present position but sustained damage, seen above, in the storm of 1953. The sea wall around the pub has since been raised.

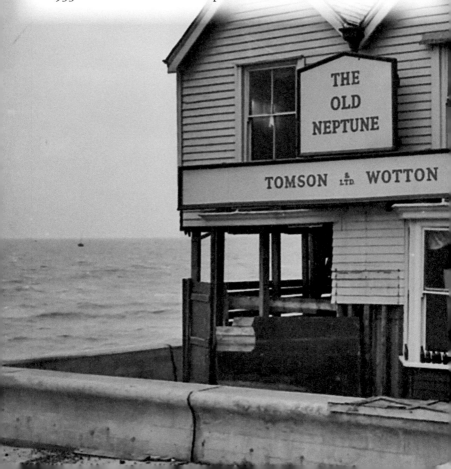

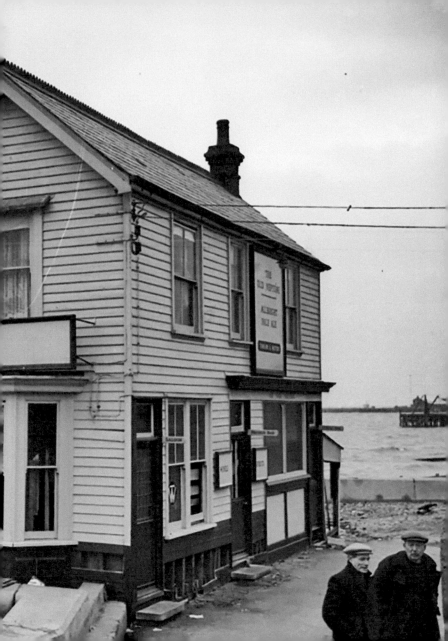

27. THE HORSEBRIDGE

This RAF Anson plane from Manston airport was forced to ditch into the sea during an experimental flight in 1936, with little apparent damage to the plane and no harm to the pilot. Note how close the sea is at high tide to the Whistable Oyster Company's building, this being before the loading of the beach as part of the town's flood defences.

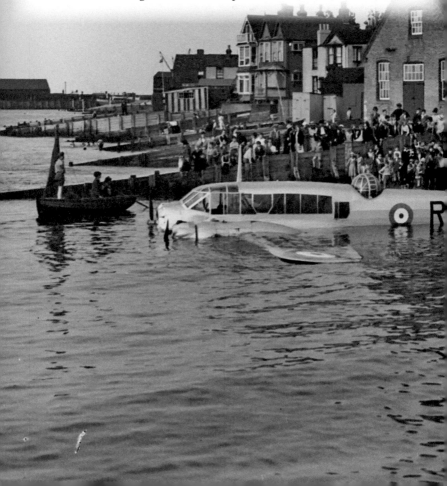

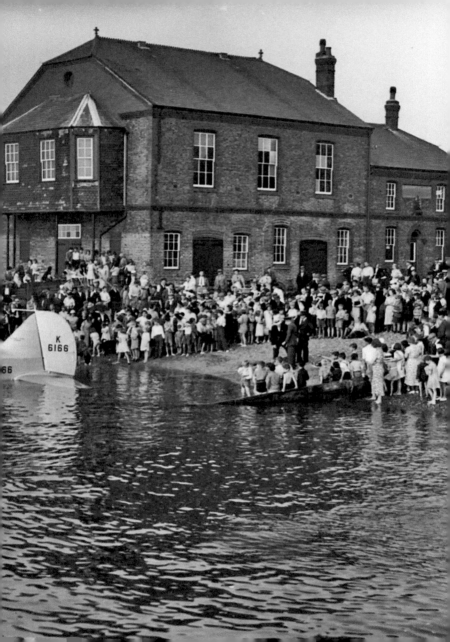

28. WHITSTABLE OYSTER COMPANY

Dating back to the 1400s, the Whitstable Oyster Company claims to be one of the oldest in Europe. Peaking in the 1850s, when supply of the native oyster was plentiful and demand strong from the poor, it sent 80 million oysters a year to Billingsgate fish market, and Royal Appointment was awarded in 1894. This building was constructed in the 1890s by Amos & Foad, local builders. Cold winters, world wars and floods damaged the industry, but interest and customers have returned in recent years.

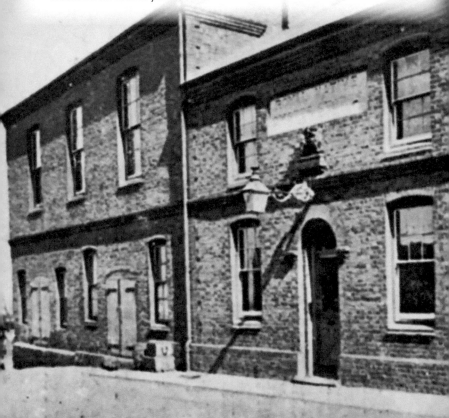

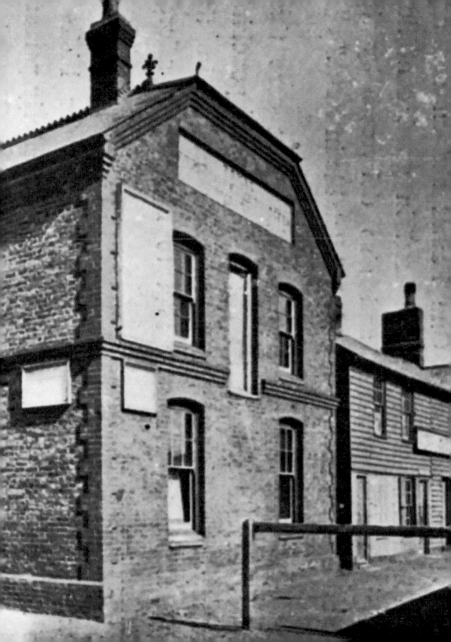

29. REEVES BEACH

Named after a merchant who rented a portion of beach to unload his goods, rather than paying a fee at the Horsebridge. Sea Wall, just behind Reeves Beach, along with Island Wall and Middle Wall were earth mounds constructed to protect the town from flooding.

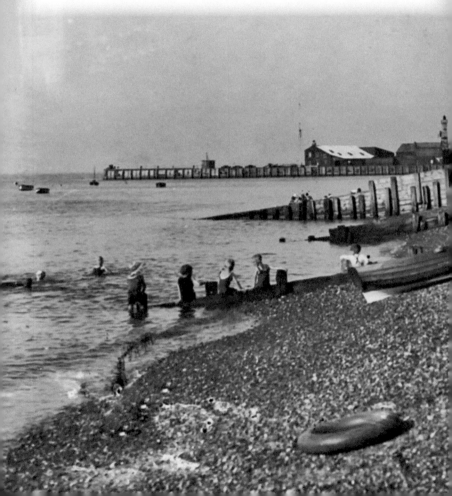

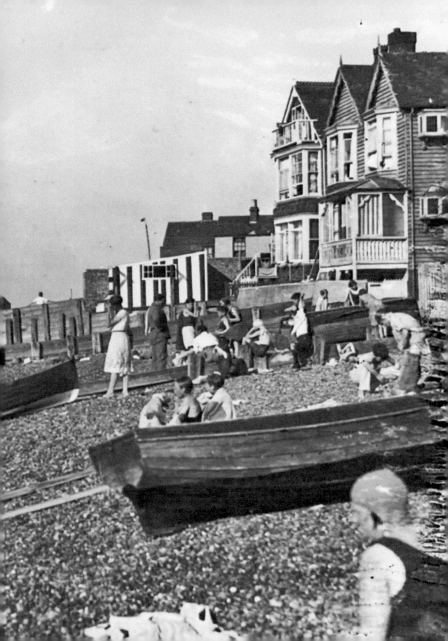

30. WHITSTABLE HARBOUR LOOKING EAST

A meeting was held with Robert Stephenson in 1828, after which Whitstable Harbour was constructed in 1831 at a cost of £10,000 5s 6d. It was built by David McIntosh and channelled through to the sea on 28 October 1831, finally opening on 28 October 1832. Colliers dominate the quay in this image from 1890, having brought their deliveries of coal from north-east ports. Today, it is still a working harbour, but fishing boats have replaced the colliers.

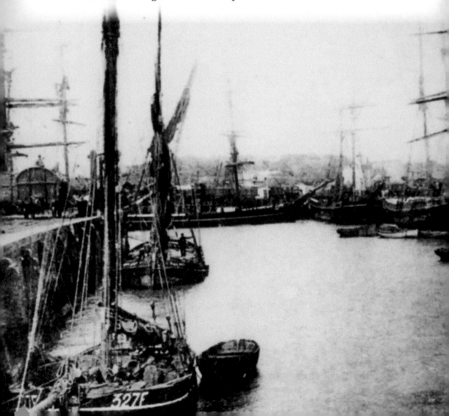

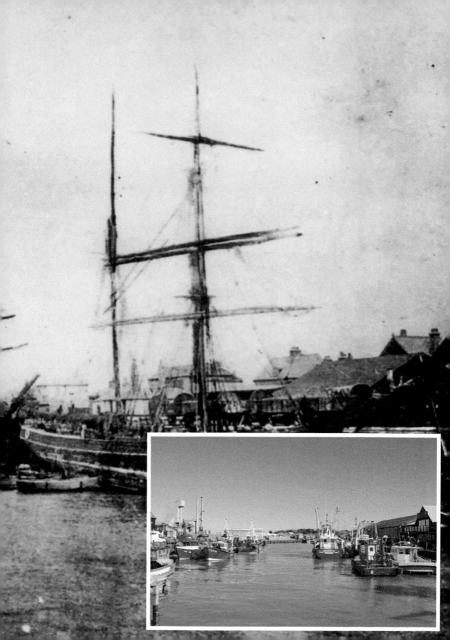

31. WHITSTABLE HARBOUR LOOKING NORTH

The *Raymond* is pictured here on the left, and the *Dolly Varden* on the right, both brigantines. The *Dolly Varden* was originally named the *Sainte Rose* and was built in Bideford, Devon, in 1871. She came to Whitstable in 1877 and was renamed in 1890, operating as a collier until her capture by a German submarine in the First World War. Her crew was removed and she was blown up in the English Channel.

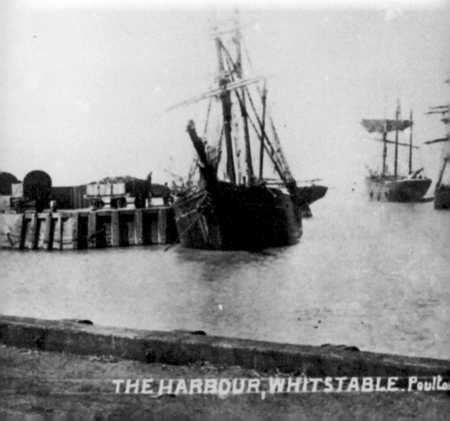

THE HARBOUR, WHITSTABLE. Poulto

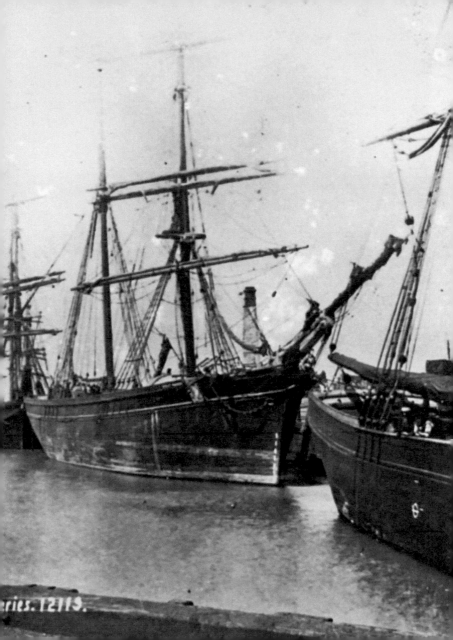

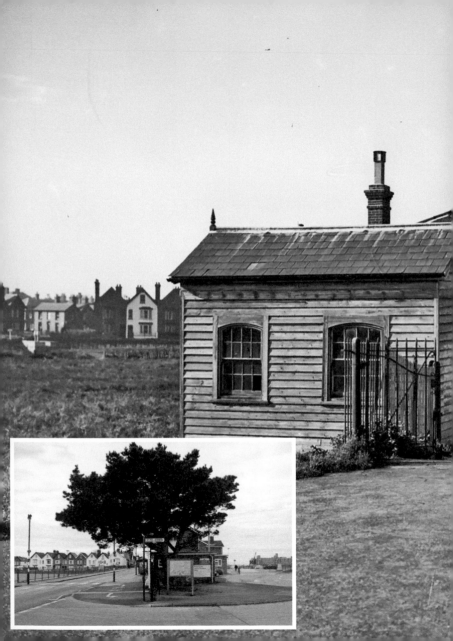

32. WHITSTABLE HARBOUR LOOKING WEST

This earlier timber building preceded the brick station in the harbour and was the terminus of the Canterbury & Whitstable Railway, which opened in 1830 as the first passenger and freight service in the world. The terraces of Cromwell Road are to the left, facing what is now Gorrell Tank car park.

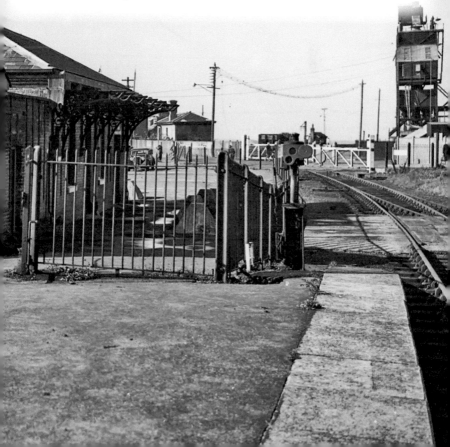

33. WHITSTABLE HARBOUR LOOKING TOWARD TOWER PARADE

The railway station was situated inside the gates at the eastern end of the harbour. Trains crossed Harbour Street via a level crossing until the station was resited in 1894 to the south side of Harbour Street, on what is now the site of the Whitstable Health Centre. Tower Parade is clearly visible to the left of the old double-decker bus and level crossing gates in the earlier shot, and it is still evident today.

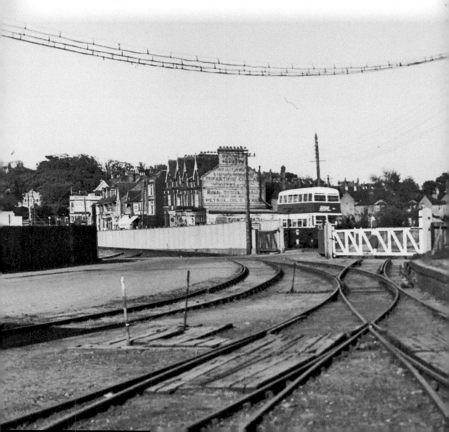

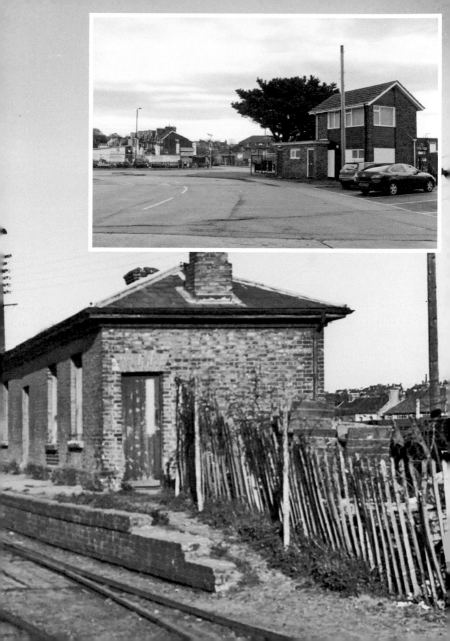

34. TOWER PARADE

The road once ended at Tankerton Green, before Tankerton Road and Northwood Road were laid, as had recently been the case in this early image, taken *c.* 1900. Queen Victoria's Jubilee Memorial Drinking Fountain was erected in front of Tower Parade in 1897 for her Diamond Jubilee, complete with an inscription, green-glazed tiles and a heavy iron drinking mug on a chain, but was gone by the 1920s. Today, a parade of shops occupies the site.

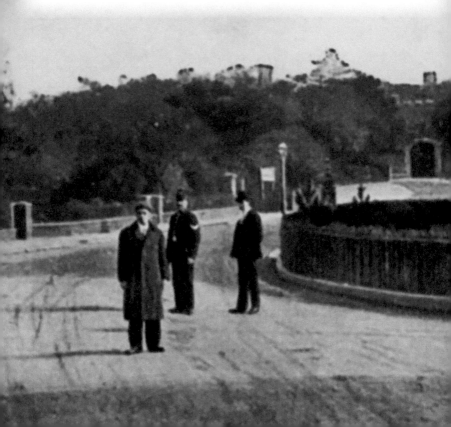

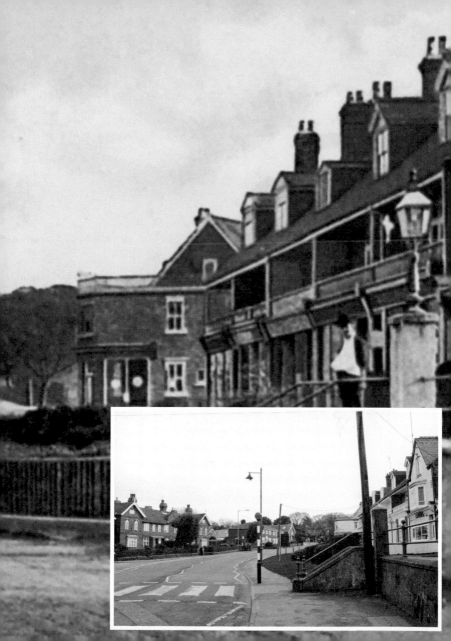

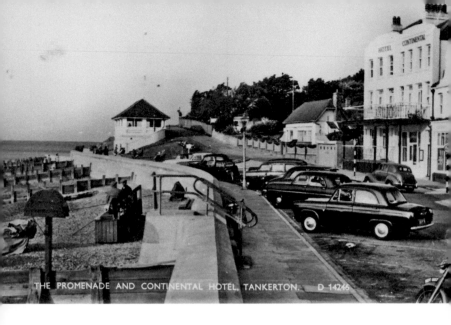

THE PROMENADE AND CONTINENTAL HOTEL, TANKERTON. D 14246

35. HOTEL CONTINENTAL

Refurbished in 1998, the Hotel Continental not only provides bricks and mortar accommodation for visitors to Whitstable, but also runs eight converted fisherman's huts as accommodation close to the beach. Before the promenade was built, walkers would take the rising path up to Tankerton Slopes or walk along the pebbles to The Street and beyond.

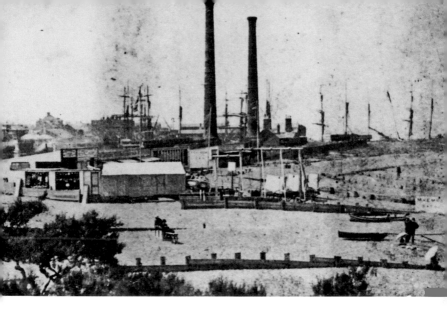

36. LOOKING WEST TOWARD EAST QUAY

The first locomotives serving the Canterbury & Whitstable Railway were coke fired. Consequently, two coke ovens with tall chimneys were built between East Quay and the beach to convert coal into coke. They produced coke for thirty-three years until coal-fired locomotives were introduced in 1880. When the ovens and chimneys were demolished in 1892, their rubble was used for the foundations of the houses and roads being built at Tankerton. Today, Brett's tall tower dominates the skyline instead.

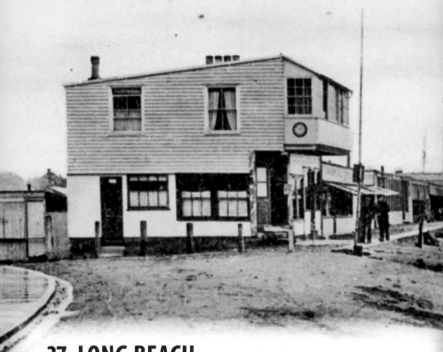

37. LONG BEACH

The stretch of beach from the harbour basin to The Street is known as Long Beach, and Tankerton Beach runs from The Street along the length of the slopes. In this early shot, the masts of sailing vessels in the harbour are visible above the buildings, and Offreddi's Tea Hut is on the far left. Today, the Whitstable Swimming Pool occupies a beachside location next to the waterfront on the corner of Beach Walk.

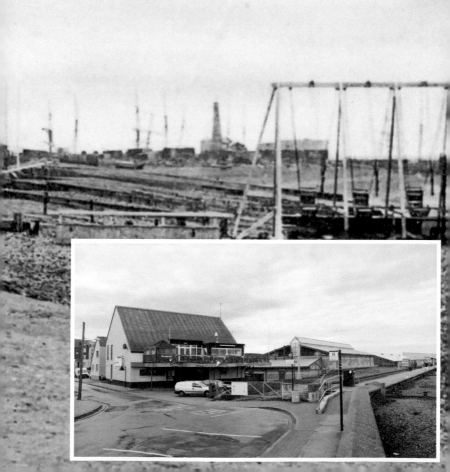

38. THE STREET, TANKERTON

A natural strip of shingle juts out from the beach, protruding around half a mile out to sea. It is only visible at low tide when it is possible to walk out along it, hence its name. It is a remnant of the River Swale valley and is a stunning natural feature of the landscape. Directly out to sea lie the Red Sands sea forts, built by Guy Maunsell to protect shipping lanes from attack by German aircraft during the Second World War.

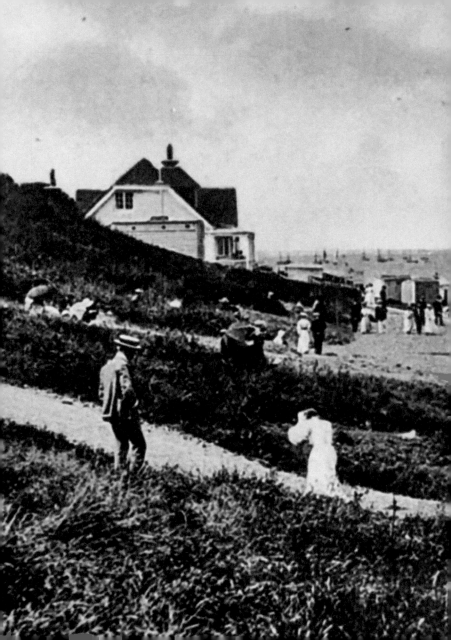

39. TANKERTON BEACH

The early popularity of the beach around 1910 is evident, as is the modesty of dress. This was due, in part, to an aversion to suntanned skin, but more importantly the social mores of the time. The bathing cabins provided a discreet place for ladies to change, which were then wheeled a short way into the sea so they could enter and exit modestly. Men, particularly those of the working class, were more immodest, willing to frolic naked despite attempts to ban the practice.

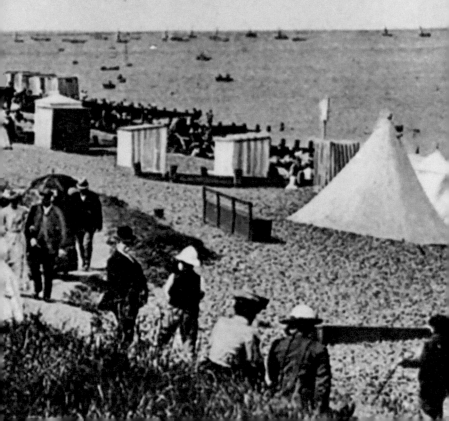

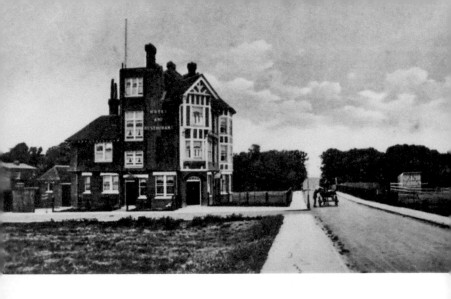

40. TANKERTON HOTEL AND TANKERTON HEIGHTS

When telephones were introduced to Whitstable, the Tankerton Hotel was allocated No. 24 and was among the first of the commercial properties and the well-to-do of the town to be connected. The business later operated as a pub, but has now been converted into flats known as Tankerton Heights.

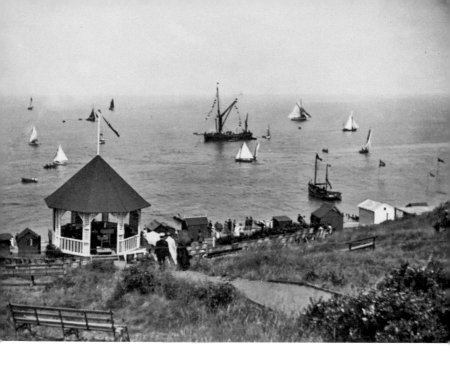

41. TANKERTON SLOPES LOOKING NORTH

Built at a cost of £85 by Thomas Porter, the bandstand on the slopes was designed by George Reeves and opened in 1912. Despite being retained initially, the sound of the Whitstable String Band was not strong enough to carry in the open air and an Anglo-American Guards Band was engaged instead. The First World War interrupted the concerts, which then continued until the bandstand was demolished in the 1940s.

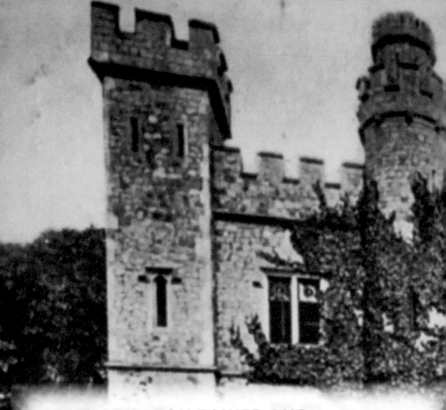

42. TANKERTON TOWER AND WHITSTABLE CASTLE

Tankerton Tower was built in 1790–92 by Charles Pearson, a London businessman, as his weekend home. Wynn Ellis MP moved his mistress here in the mid-nineteenth century, and Albert Mallandain added the large billiard room in the 1920s. In 1935, the building was purchased by the local council and used as their offices for the next forty years. It was also renamed Whitstable Castle. A lottery-funded project restored the castle in 2008, and it is now used as a community resource.

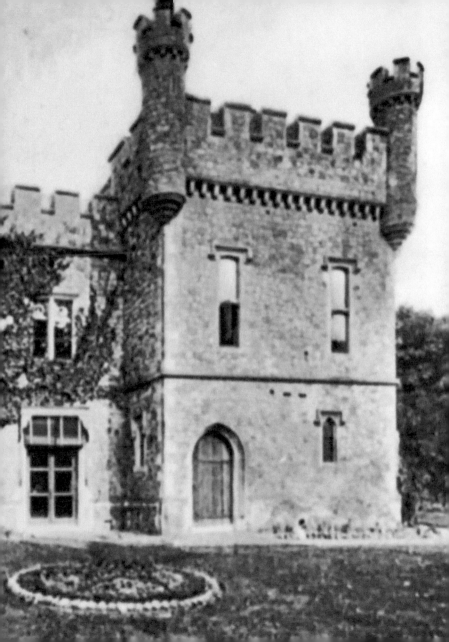

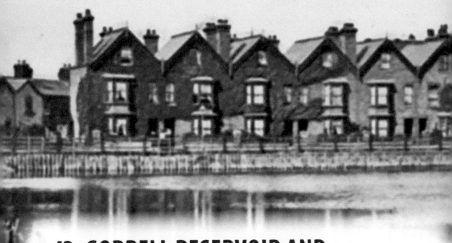

43. GORRELL RESERVOIR AND GORRELL TANK

This early photograph of the Harbour Street end of Cromwell Road is taken across the Gorrell Reservoir, known locally at the time as the Backwater. Built to flush silt from the harbour, it would fill with water from the Gorrell Stream and drain with the tides. It was largely ineffective, and the harbour is regularly dredged today. The reservoir was concreted over in the 1970s with the installation of a tank below; the area is thus now known as Gorrell Tank.

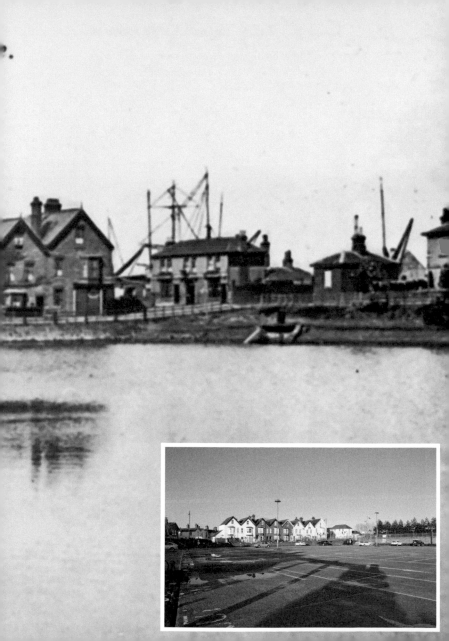

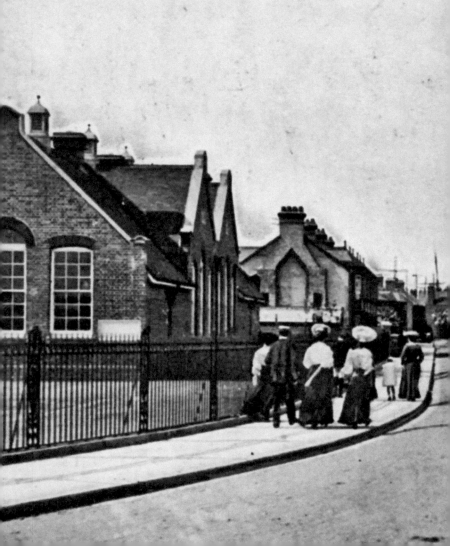

Cromwell Road, Whitstable.

44. CROMWELL ROAD NORTH

Westmeads Community Infant School, seen here on the left, was commissioned by the newly established Kent Education Committee, based at Maidstone and built in 1904. It replaced another infant school in Albert Street, which dated from 1879. The first state school in town was the Oxford Street School, which opened in 1877. The hall on the right is St Peter's Church House, acquired in 1937 for £500.

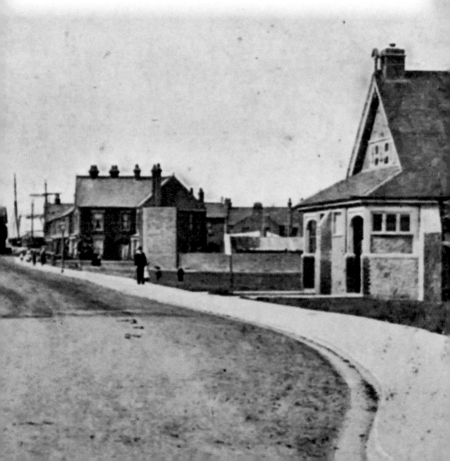

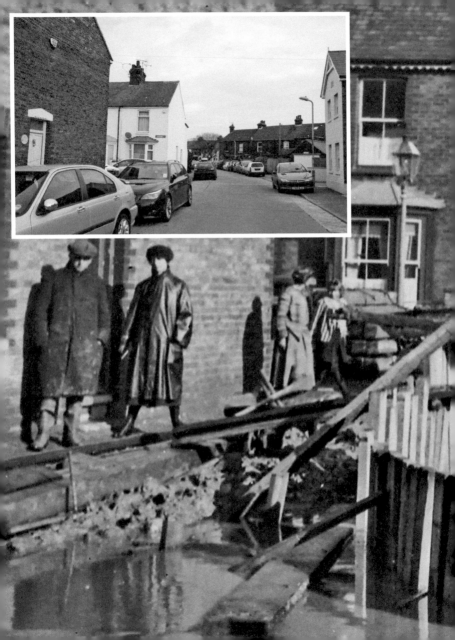

45. GORRELL STREAM AND STREAM WALK

The lower areas of Whitstable are built on the dried delta of the Gorrell Stream. The open dyke that wound its way through the centre of town was concreted over in the 1920s, and this old image is likely to show work in progress. Today, it is possible to walk along it from Belmont Road to the end of Cromwell Road, where it flows unseen into the Gorrell Tank.

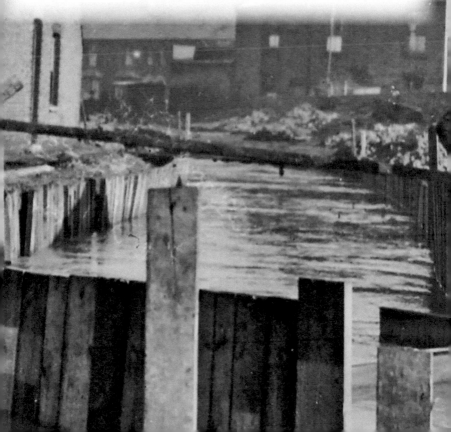

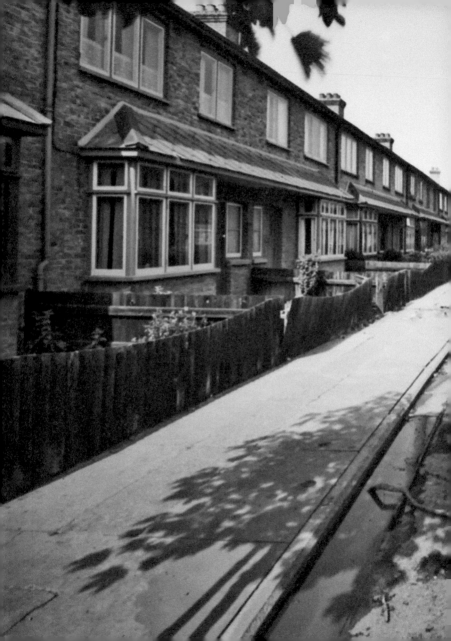

46. ACTON ROAD

New houses in Acton Road were sold for £475 in 1926; £75 down and
15s 3d a week thereafter. Before the official declaration of war on 3
September 1939, the evacuation of 4,000 children from Rochester
to Whitstable had begun. They were removed in the belief that
only industrial areas were at risk of being bombed. Even so, beach
huts were replaced with steel and concrete structures, and military
exclusion zones were established along the coast.

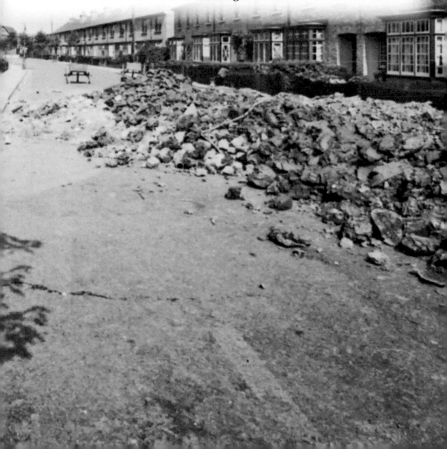

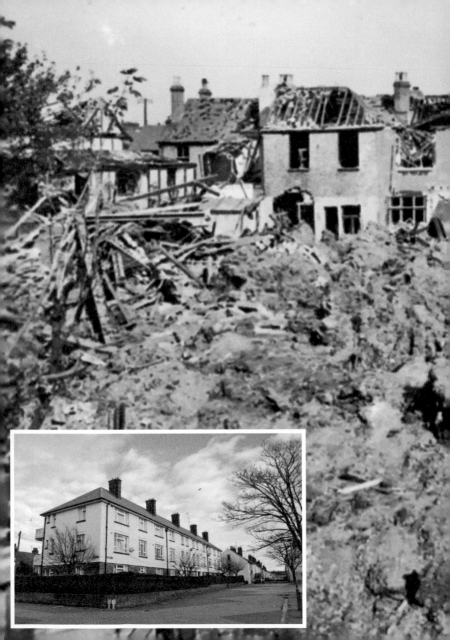

47. VICTORIA STREET

This area of town was destroyed by a heavy calibre bomb on 11 October 1941. Dozens of houses were destroyed, and two people lost their lives – both in the vicinity of a fish and chip shop. The area was redeveloped in 1951 when the Victoria Street flats were built, together with a small residents' car park on the corner of Victoria Street and Regent Street.

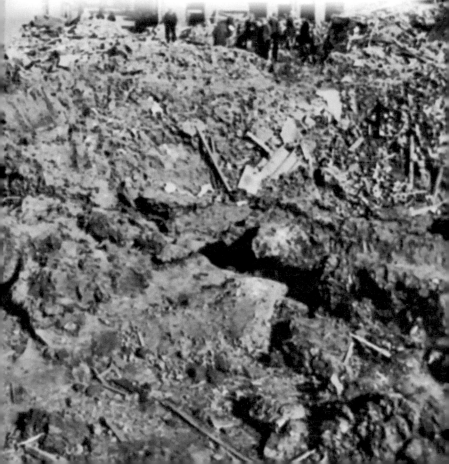

48. HARBOUR STREET

A fire at this end of town in 1869 destroyed seventy-one buildings in Sea Wall, Marine Street and Harbour Street, with the cost of the damage estimated at £13,000. They were rebuilt, and Harbour Street, with its narrow eastern end widening towards the west, is now home to Whitstable's enclave of independent boutiques, booksellers, restaurants and cafés. It continues to be a popular destination for shopping and dining.

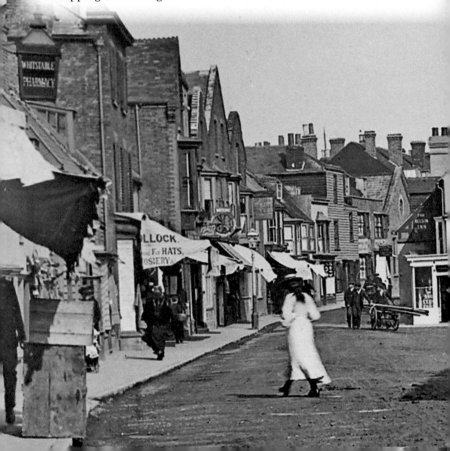

ACKNOWLEDGMENTS

Writing, as ever, is a team effort, so thank you to Brian Hadler for his support with the original research for *Whitstable Through Time*, as well as Lin and Tony for their help and assistance on this new venture.

ABOUT THE AUTHOR

Kerry Mayo is a writer and photographer who also runs a successful business in Whitstable. She has published *Whitstable Through Time*, a photographic/historic work looking at the development of Whitstable over the last 120 years. Her novels *From This Day Forward, Catch, Pull, Push* and *Her Soul To Keep* are available on Kindle or from Amazon. Follow Kerry's blog at kerrymayo.com or on Twitter @kerrymayo75.